...a sea-change into something rich and strange —Shakespeare

SE

Robert Adams

Tom Baril

Thomas Joshua Cooper

Lynn Davis

Liz Deschenes

Robbert Flick

Roni Horn

Stuart Klipper

Fernando La Rosa

John McWilliams

Tom Millea

Michael O'Brien

Doug and Mike Starn

Iain Stewart

Hiroshi Sugimoto

James Welling

Randy West

Hiroshi Yamazaki

A CHANGE
The Seascape in Contemporary Photography

Trudy Wilner Stack

Essays by James Hamilton-Paterson and Trudy Wilner Stack

Center for Creative Photography
The University of Arizona
1998

Center for Creative Photography
The University of Arizona
Tucson, Arizona 85721-0103
520-621-7968 Fax 520-621-9444
http://www.ccp.arizona.edu/ccp.html

Available through D.A.P./
Distributed Art Publishers, Inc.
155 Sixth Avenue
New York, New York 10013
212-627-1999 Fax 212-627-9484

ISBN 0-938262-32-7
Library of Congress Catalog Card
Number: 97-78397

Designed by
Reliable Design Studios, Inc., New York.

Printed by Gardner Lithograph.

This catalogue accompanies a traveling
exhibition of the same title organized
by and held at the Center for Creative
Photography, The University of Arizona,
March 8 - May 24, 1998.

Sea Change is supported in part by
Lannan Foundation, the National
Endowment for the Arts, and the
Arizona Commission on the Arts.

Cover: Liz Deschenes, *Color Study #11*,
1994-95 [detail]

table of contents

sea change *n.* **1.** A change caused by the sea. **2.** A marked transformation.

The cultural impact of oceans

James Hamilton-Paterson

Just as the ocean's visible face hides processes of infinite complexity, so do modern images of it encode a concealed cultural history. The rectangular frame of a painting or photograph has so often contained that classic view: sea at bottom, sky at top, horizon separating two bulks of colour and texture. But the artist's eye into which this view has poured has seen very different things at different periods. The sea and sky of the seventeenth century Dutch painter Jacob van Ruisdael were not those of John Constable, nor his those of J.M.W. Turner or Whistler. Seascapes, like landscapes, change their meaning from one generation to the next as the preoccupations of each age shift focus.

Until the early eighteenth century and the beginning of the Enlightenment, Europeans tended to view the natural world as through a pair of spectacles whose twin lenses were religion and the Classics. Where the sea was concerned, the religious view was predominant. (We must distinguish from the start between those who worked on or by the sea—mariners, fishermen, beach- and coastal-dwellers—and the vast majority who lived agricultural or city lives. Sea-dwellers everywhere have always lived by a mixture of practicality and superstition.) The fact is that the ocean filled most landlubbers with an uneasy distaste which had more complex origins than merely the notorious dangers of sea travel.

This old-fashioned, orthodox Christian view of the sea derived from the Old Testament. In addition to its obvious perils, the ocean had about it something evil and *unfinished*, a reminder of the primordial chaos that had reigned before the opening of Genesis. The raggedness of coastlines was worrying. The land seemed just to peter out with no regard for smooth elision; it was not easy to discern the reason behind the way the Creator's hand had allowed *terra firma* to break off in so arbitrary and defeated a manner. Inlanders emigrating as colonists to the New World were no doubt overjoyed to see a line of land creep up over the horizon; yet remembered horrors of the Atlantic crossing and the place of their landfall greatly influenced early Americans' vision of New England so that the idea of a coast became associated with that of a wilderness.

Had they read Thomas Burnet's book, *The Theory of the Earth* (1684), they would have known there was a sound theological reason for this. To him, it was significant that there is no mention of the sea anywhere in the Biblical account of the Garden of Eden. It was rigorously excluded from the earthly paradise. The sea as we now know it came into being only after Noah's Flood and was God's reminder to us of what would happen if we ever again incurred His wrath. So He deliberately made it terrifying and grotesque: a godless abyss surrounded by jagged coastlines and reefs and able to rise in sudden storms of overwhelming power, during which it could break out of its confines like an untamed beast to swamp the land. The sea thus gave off a certain moral sternness, its punitive potential kept on a leash by Divine will.

It was largely science that put an end to this view of the ocean. The natural sciences—and especially geology—which began to take shape in the first decades of the eighteenth century removed more

and more phenomena from the gaze of dogma and superstition and subjected them instead to that of Reason. In his *Historie et Théorie de la Terre* (1749), Georges Buffon became the first to propose that the Earth had to be far older than the 6000-odd years which the Bible texts suggested. This was daring, part of a profound shift of viewpoint which was taking place all over Europe. Indeed, the nineteenth-century historian Jules Michelet later went so far as to claim wittily that the sea had been invented in 1750. It is tempting to look back and try to identify a precise moment when intellectuals were "liberated" from the influence of an old theological system. Such a moment never happened, of course. Revolutions in thought are never as linear or simple as they appear to hindsight. In this instance change was spread over nearly three centuries and across several cultures. How Western attitudes to the sea moved from a religiously inspired disgust to Hollywood's erotic frolicking in its shallows is a complex story. Its various strands include artistic and aesthetic theory, science, medicine,

oceanography, technology, sociology, fashion, demography, railway building, economics, photography and much else.

For one thing, it has become clear that science does not simply oust religion. With certain exceptions, beliefs change in order to accommodate science. Some degree of diehard fundamentalism always persists, no doubt; but the majority of religious people (which would certainly have included most of the eighteenth century's natural scientists) grew to accept the new perspectives science was bringing to the natural world. Instead of standing as a menacing reminder of Old Testament doctrine, nature—in particular, seascapes and mountains—began to appear as a manifestation of the Sublime. Nature's ability to fill people with feelings of wonder was an earthly token of the infinite marvels that extended throughout creation. The Romantic movement (which included figures as diverse as Goethe, Forster, Friedrich, Hölderlin, Wordsworth, Sénancour and Constable) established this attitude in an aesthetic so powerful it can move us to this day. Thoreau at Cape Cod marvelling at the sea's

constantly shifting colours was a natural inheritor of this tradition. The idea that the ocean might be a source of learning and earnest pleasure as well as of awe is the forerunner of our modern attitude towards nature. It derives directly from reactions to the proliferating discoveries made by natural science, and was a tribute to the popularity of economically priced microscopes and the mid-nineteenth-century fashion for "botanising" in the rock pools along Europe's coasts in order to stock "aquaria" in suburban drawing rooms.

Meanwhile, in the early eighteenth century, medical theory had begun advocating sea bathing as a cure for melancholy. The shock of cold water was held to be invigorating in itself, but it was also believed that the sea contained a strengthening ingredient. Travellers had noticed that sailors and beach-dwellers tended to be very hardy. In Britain, at any rate, this observation contained an anxiety about class. The more thoughtful of the urban aristocracy and social élites worried about their physical state, which was generally interbred,

under-exercised and overfed. Effete and full of "spleen" (which today might be diagnosed as chronic boredom), they foresaw that they might eventually become marginalised or even die out, pushed aside by sheer peasant fecundity. Suddenly, it seemed, a way towards vigorous good health might lie in immersing their bodies in the waves and doing mild battle with the elements. Various medical regimes soon established themselves, many becoming very popular and associated with coastal towns which by the end of the century had duly turned into resorts. It was this touting of the medicinal virtues of seawater that led to the invention of the beach, which up until then had merely been the shore.

The beach as a setting for the earnest pursuit of health quickly acquired overtones of sensuality. From the moment in 1735 when the first bathing machines appeared at Scarborough in Yorkshire and ladies began bathing, the foreshore steadily became eroticized. In the following century the counterpart of the affordable microscope was the cheap telescope, which became a standard piece of masculine beach equipment. A little later

still, the railways and the democratization of mass transport brought increasing numbers of day-trippers and holidaymakers to the coasts of northern Europe and New England. It was soon noticed that codes of behaviour were noticeably relaxed down on the sands. This effect was much lamented by churchmen and other arbiters of public morals, but in vain.

A strange kind of freedom reigned by the sea, which had always had connotations of lawlessness and anarchy, even as its own moods seemed beyond control. The beach came to represent time off—not just from work, but from stultifying social conventions. People came in trains, pale from filthy industrial towns, and stepped out into fresh air, sunshine and bracing waves. It was largely on the coast that urban folk rediscovered Nature. They flirted; they invented silly games; they sat in the sun or paddled. It was a tantalizing simulacrum of freedom. Later, they buttoned everything up again and boarded their trains, rearranging thought and behaviour so by the time they reached town they were once again seemly citizens. But

they had feasted their eyes.

This voyeuristic element of human interaction with the sea's margin has been consciously present ever since the beach drew the line between clothing and nakedness and came to represent a special terrain where social norms were reversed. Nothing made this so clear as 1960s beach movies like *How to Stuff a Wild Bikini*. Here, a city-suited, camera-toting man snooping around the beach is glaringly out of place. He is surrounded by beach bunnies and mocked for his prurience, even as the film's audience themselves become the voyeurs. In fact, the association of the sea with the erotic has been faithfully cemented by popular culture in the twentieth century, not least by Hollywood (itself a subtropical town on the shores of the Pacific). Travellers' stories of exotic parts of the world had long been influencing popular imagination, arousing speculation about "native" societies with liberal attitudes towards sex. The idea of polygamy became something of a Western obsession, and the fascination Tahiti had for Gauguin was not misunderstood.

Precisely the same interest can be traced in films like *South Pacific* and a thousand others. It is no accident that the bikini took its name from an atoll. Tropical islands became a particularly favoured locus for fantasy because they licensed so many powerful erotic images. They were safely far from "civilization" so there was no fear of being observed. Their climate made semi-nudity essential, while the sea's balmy warmth invited languorous bathing. If additional excitement were needed there was always the possibility of buried treasure. From these ingredients were concocted dozens of swashbuckling pirate movies which were also vehicles for that then-fashionable type, the dangerous Latin lover. Owing something to the ghost of Rudolf Valentino, he was bronzed and dashing, a swarthy buccaneer as beyond the law as the sea itself.

We note that he was *bronzed*. The preservation of a flawlessly pale skin had once been a sign of good social class, at any rate in northern Europe, since it was evidence of a life lived largely indoors, proof that there was no need to earn a living.

It was peasants and other labourers who were brown. This glib equation was upset by the Industrial Revolution, which increasingly swallowed up agricultural workers and put them to work in factories, often in conditions hardly distinguishable from those of prison. Henry Mayhew's harrowing descriptions in *London Labour and the London Poor* (1851-62) not only provided a central text for social reform, they overturned the traditional association of paleness with indolence and established a link between paleness and labour ("unhealthy pallor"). Since city doctors were sending more and more of their patients to the coast for the sun and the salt air (believed good for TB), a facile parallel was set up whereby skin colour became a sort of litmus test of health, which was soon understood to mean the browner the healthier.

Looked at from a broader angle, one could say that all these changes in social attitude towards the sea were part of a general intellectual and scientific preoccupation with the *taming*

of Nature. The natural world was steadily being subjugated by knowledge, technology and familiarity. The history of oceanography illustrates this well. Put briefly, much of early oceanography involved going ever deeper into the sea; and the changing technology that made this possible steadily mediated the view. For instance, the so-called "azoic" theory, which was still seriously held until halfway through the last century, stated that below a certain depth the ocean could not support life. Yet new designs of sounding and sampling devices gradually revealed that there was life in even the deepest ocean. This brought the "godless" abyss firmly into the biosphere, while oceanographers occupied themselves with classifying the diverse species of marine life, with currents and weather and mapping, with fisheries and geology and much else. People were themselves beginning to venture beneath the sea's surface, too. A crude diving bell had been used for salvage as early as 1538; but with the coming of reliable diving suits supplied

with pumped air, to say nothing of submarines (first used extensively in World War I), the ocean's upper fifty meters could be sampled and explored firsthand with some precision. Throughout history the sea's surface had been used as an arena for warfare. In the twentieth century its depths were opened up for the same purpose, as well as for "pure" research. Marine science and the military are today often indissolubly linked because the sea's depths are also a potential battleground. This has meant that research which once would have seemed the innocuous province of oceanography may be backed by military funding and conducted by scientists whose findings remain classified. (This is especially true in the fields of communications and sonar.)

Over the last fifty years a profound change of attitude towards the natural world has taken place as some of the consequences of the interaction between the planet and its dominant species have become better known. The gap between scientific knowledge and public understanding of nature always was

considerable, the sea inevitably being least understood. (One area in which a grudging respect for nature has taken over is that of beach sunbathing, nowadays increasingly seen as an ironic tradeoff between healthiness, fashion and skin cancer.) Popular awareness of how human activities can in turn damage even so vast a body of water as the ocean has been much increased by crusading books like Rachel Carson's. Yet it is really only in the last decade that most people have become concerned about the possibility of irreversible destruction (such as that of the world's coral reefs) as well as of collapsing populations of biota (the demise of the cod fishing industry on Newfoundland's Grand Banks was a notorious omen).

Suddenly, the Western attitude towards the ocean has merged with a more general view of the natural world. In place of simple awe there is disquiet at possible catastrophic loss. For all their advances, oceanographers are the first to admit that our understanding of the sea is still rudimentary. Faced with the ocean's inconceivable bulk, it is all too clear that it will

always remain beyond the scope of "can do" technological fixes.

Lately, therefore, people have found themselves standing somewhat humbly in an entirely new relation to the sea, though it is more than the traditional sailor's humility. This new stance is reflected in the images that photographers have been making, so beautifully exemplified in this present exhibition. The complete absence of living creatures in this selection is deliberate. The images are all of "pure" seascapes, entirely free to deal with such things as colour, light, shapes and textures. Fifty years ago classic images like these might well have been given titles that invested the scene with human affect ("Loneliness", "Waiting", "Silence", "Fury" etc.). Now, it seems, the sea is finally being allowed to make statements of its own, and we are amazed at how moved we are by them. Instead of being mortals confronting the Sublime with awe at our own insignificance and transience, we face an ocean speaking shockingly of its own fragility. The sheer richness of the cultural clutter we

now bring to it, its associations with holidays and travel—even with private erotic memories—may give us the illusion that we have assimilated the sea to the point of familiarity. These photographs remind us that we have not; that it still moves in us and haunts us as something both intimate and quite inhuman. Its dogged remoteness from us, like its beauty, is endlessly poignant.

Perhaps we are witnessing the beginnings of a new aesthetic of the ocean. It is not simply that, as late-twentieth-century gazers at the sea, we can better understand how its immense bulk and power contain both delicacy and vulnerability. We are also more likely to appreciate how dependent we are on it for our species' survival. For the first time in history this dependence has little to do with either travel or fishing. Present-day seascape photography may necessarily focus on the ocean's protean surface, but it is informed by an inheritance of scientific knowledge about its depths. This knowledge subtly changes the view, just as Renaissance artists' studies of

human anatomy led to a new sensitivity to their sitters' faces, skin and physique. When from a ship's rail we watch the mesmeric dance of waves to the horizon and lose ourselves in endlessly crumbling rafts of foam, the restless tufts of colour, we may justifiably feel the sea as an extension of our own bodies. As the sea is increasingly revealed as the planet's bloodstream, so inevitably it becomes ours as well. The Western world's gradual immersion of its body into the ocean during these last two centuries—for medical, scientific and finally erotic purposes—has bestowed corporeality on the sea itself. Maybe because we now recognize the ocean as our ancestral home it has this emotive fascination for us, like that a mother country has for its long-scattered diaspora. In its shifting moods and constant movement it seems alive, if not sentient. Insistently it offers aesthetic and sensual ravishment with underpinnings of annihilation: very much an art form for its time.

The eye of the earth

Trudy Wilner Stack

Let there be a firmament in the midst of the waters, and let it divide the waters from the waters.

—Genesis

That we may live now with some
Curiosity and hope
Like pools that soon become part of the tide

—John Ashbery

In a culture deluged by fabricated imagery, where do image-based artists find a place to see anew? Where do they clear their view of product and promotion; of sensationalist, simple-minded messages proffered by a tangled network of international powers themselves trading in, and on images? Where does an artist go to reflect on the status of our habitation of the planet, or to examine his or her own spirit? And where can that artist see most purely the essentials of the visual—the language of color and light, surface and form, opacity and transparency, deep space and poignant detail? It is the sea, moving at the edge of our cheapened shores, that once again invites contemplation. What but the ocean can so commandingly describe itself, bespeaking designs much grander than our own, and yet present an open panorama for our individual projections?

The sea, while vulnerable to our interventions and exploitation, appears constant and immense like no other place. It is the earth's most overwhelming physical presence, covering seven-tenths of

the globe. Presenting endless contradiction, it is equally a respite and a threat. We flock to its shores to break from daily grinds and set out upon it on cruises, floating fantasy escapes. And yet we fear its harsh realities—its tidal waves and vicious hurricanes, and the power of its depths to take away our breath. It is romantic and it is desolate, it is eternal and it is ever-changing. The ocean is a place where we stare out, where distance itself takes shape, where our eyes steadily play over the waves like the sun and moonlight that illuminate our reverie.

The sea exerts a forceful magnetism, a compulsion as sure as its own tides, one that tempts our appetites for the epic and profound. Its magnificent expansive vistas, the spread of atmosphere that defines its topside watery margins, its endlessly shifting moods, its infinite motion—these are enchanting features that engage those who picture the sea, in this case, those who photograph the sea, working within and against a tired, seemingly forgotten genre: the seascape. For until recently, such a great and rousing subject had

become a worn convention in art.

Many categories of visual representation in the history of art are perennial, that is, classical. Allegory, Still Life, Portraiture, and Landscape—these signify rich traditions that alternately endure disdain and neglect, then enjoy revision and revitalization. These subject classes are large embracing headings that harbor many contemporary artists and provide rubrics for critical reevaluation and comparison as we ceaselessly take the aesthetic temperature of our times. Among these recurring categories, what has become of the Seascape? Has the passage of the age of discovery, the complete circumnavigation of our wet orb and the advent of air travel, made the sea an obsolete, secondary subject or just more elusive? Maritime life—once the dangerous occupation of adventurers and rebels, of burly men whose collective tales and chanties constitute a literary genre of their own—is now a workaday industry. Commercial fishing, oil drilling, container shipping, and navy maneuvers now involve tremendous vessels that operate in profuse

numbers and on businesslike schedules. They rarely bow to the elements, but rather threaten them—and even so, do not captivate the popular imagination like the great sailing ships of the past.

While the ship was demoted from the romantic to the utilitarian, the pure seascape—the subject of this project—the picture of the sea that is unconcerned with boats, or any marked evidence of human activity, animal life, or coastal terrain, has become a hackneyed painting mode, required decor in seaside motels. Typically, an impasto of white paint unfurls and scatters out of ocean-blue crashing waves, perhaps accompanied by a lifeless sun, an array of cumuli, or an errant seagull. Photography too, has its share of cliché seascapes on calendars and postcards. Perhaps a bit less stylized than the canvas versions because of their connection to real action, they are still predictable and uninspired by virtue of their sameness and standard formulation. Very late in the twentieth century, the term "seascape" conjures up these kitsch images more quickly than the powerful art of Turner, Whistler or Homer. And the definition of seascape as simply a view of the sea is rare in current usage.

Out of this history, or despite it, comes contemporary art's serious, returning interest in the sea as photographic subject. That it comes at the end of the century from artists working in diverse strains of current practice, and after many decades of only mild attention, seems worthy of examination. What does the vision of the sea help us play out on the brink of a new millennium? Does its blankness offer a tabula rasa for creative minds in an era that aches for a fresh start? Does the undulating, indefinite surface that ranges from deadening, flat and ordinary calm to wild turbulence and hulking swells, provide a stage for the heightened thoughts and emotions, personal and public, that mark a society's collective mood swings on the edge of a new age?

The sea is a site of paradox. It may be the ocean's new vulnerability that links us to it again, sharing as we do an uncertain future of accelerated evolution and planetary change. At the same time, despite our abuses, we cannot extinguish the sea as we can animals and plant life; instead the sea threatens to overwhelm us with our own heedlessness. At some juncture, an altered sea (experiencing "the removal of billions of tons of living creatures…and the addition of billions of tons of toxic substances")[1] will uncaringly reckon with us. "The staring unsleeping/Eye of the earth,"[2] the sea seems to us our planet's watchman, and the agent of its retribution as well. As the biosphere warms and the polar caps begin to melt, the oceans will expand to overtake our safe position on the ground, washing away islands and coastline like pebbles drawn into the tow of the receding surf, unrecoverable. Under pressure, the great deep is again a player in human drama, as in the sea narratives of old. Now three billion years old, its ability to sustain and annihilate life continues, but in a state of flux, the result of man's aggressive course of short-term self-interest.

Another paradox: these weighty, shifting signifiers reflect the times, yet the image the sea presents is uniquely unchanged. The primordial, the antique, the medieval, the Enlightened, the Victorian, the Modern, the 21st century seascape—all present a remarkably uniform vision. The aspect of a field of water, contained by a horizon and an ascendant sky, appears much as it did to Odysseus, or more recently to seventeenth-century Dutch painters, Japanese woodblock master Hokusai in the early 1800s or the first important photographer of the sea, Frenchman Gustave Le Gray, who worked on the theme in the 1850s. It is the meaning, not the look of the sea, that has significantly changed over the course of man's relatively short history.

This surface continuity makes yet more intriguing the revival of seascape aesthetics. How does the contemporary artist, living in a time that privileges new ideas and the art of surprise and theoretical savvy, justify preoccupation with a subject as classical and tried as the pure sea? The sea, it seems, is self-renewing in our art as well as in its nature. When we examine the work in this exhibition (which ranges broadly in focus, technique and scale), distinct parallels in aspect and effect connect a group of often disparate artists. Whether self-described seascapists or not, and for a host of reasons, Robert Adams, Tom Baril, Thomas Joshua Cooper, Lynn Davis, Liz Deschenes, Robbert Flick, Roni Horn, Stuart Klipper, Fernando La Rosa, John McWilliams, Tom Millea, Michael O'Brien, Doug and Mike Starn, Iain Stewart, Hiroshi Sugimoto, James Welling, Randy West, and Hiroshi Yamazaki collectively testify to a timely resuscitation of a seductive and headily beautiful genre.

Never a documented, mature photographic concern,[3] pure seascapes also rarely appeared as a progressive mode in American painting after Impressionism and Romanticism had played themselves out by the early teens. With the exception of Modernists Marsden Hartley and John Marin, who "were virtually obsessed by the power and dynamic energy of the sea,"[4] and some sustained interest in the subject by Milton Avery and a few others, it was not until about 1970 that twentieth century artists began to innovatively trouble with the sea again.

Vija Celmins and Gerhard Richter were two whose imagery presages the work represented in *Sea Change*. Whether painting or

drawing from photographs, both incorporate photographic seeing into their art. Richter, whose interest in the seascape genre peaked between 1969 and 1973, painted naturalistically-colored, soft focus paintings from archetypal, romantic photographs because "I felt like painting something beautiful."[5] Richter went further with his photographs of the sea by painting directly on the prints and, for his epic tableau *Atlas*, created seascapes by splicing sea and skies from different images, subverting the halving effect of the horizon line. These compositions, reminiscent of a technique used by Gustave Le Gray in the nineteenth century, challenge standard views and surprise expectations while remaining "beautiful."[6]

By 1975, Richter added gridded color seascapes to *Atlas*, small sixteen-print typologies of incoming surf on planar stretches of beach (or just rippling sea surfaces) that are topped by companion blocks of sky. These straight shots closely recall another antecedent to *Sea Change*, the Cape Cod beach photographs of Harry Callahan from 1972 to 1974. These pictures cap

forty years of photography by coalescing his career-long interest in the "water's edge." Callahan wrote that this Beach Series speaks to "nearly every artist [who] continually wants to reach the edge of nothingness—the point where you can't go any farther."[7] While Richter and Callahan would seem to share little conceptually, they both returned to the delimitation of the sea and its stirring appeal as a metaphor for pushing the edge.

Because of its primary nature, the sea can subsume questions of artistic alignment; few artists can transform ocean waves and waters substantially enough to markedly differentiate their sea imagery, from postcard to postmodern. Sol Lewitt's series of sunrises and sunsets off the Amalfi coast from the early eighties, Richard Prince's 1985 grid arrangement of cresting waves, and Robbert Flick's multi-image sequence of a wave rolling into shore begun in 1982, present themselves similarly, but represent extensive shifts in intention and context. How do we distinguish one static flat horizon line bordering a calm sea from another; one oily undulating swell rising

into clouds from another; or one frame-filling lustrous ocean surface from another? It is first from a larger understanding of the artist's work that we can locate the particular reasons the sea has been employed and a time-honored paradigm has been invoked. And then when experiencing the art object (these works being exceptionally subtle and more dependent on the characteristics of their physical presence than many contemporary photographs), we can accurately read details in interpretation and production that help to further distinguish the origins of the image.

The nineteen artists represented in *Sea Change* have demonstrated a range of approaches, and the works selected for the exhibition and this publication partially evidence their differences and commonalities. In order to advance the project's aesthetic and because of practical size limitations, works that might lead the viewer away from the pure seascape, or reveal a deeper insight into each artist's individual processes and orientation, were not included. But not one artist objected to being placed in this study of a returning

genre, now particular to photography. Each one responded to the seascape model as a not inappropriate overlay, though rarely was it integral to their own motivations.

These artists do not have complex, theoretical underpinnings to their sea imagery. Their explanations and discussions of content are straightforward and often remarkably reverential. The following is a selective synopsis of their more general comments (many common among them) on the attraction and nature of the sea and its interest as a subject for their art.[8] Robert Adams speaks of its overwhelming beauty, unfailing mystery, its ability to quickly change and be always new, and its hypnotic effect. Tom Baril sees the ocean as magical and responds to the minimalist beauty of a scene of only water and sky. Thomas Joshua Cooper is compelled by the ability of waves to bespeak what lies below them and to reveal the place from where they have come. He also refers to the gripping margins the sea creates and its use as a Buddhist metaphor for the void. Lynn Davis relies on the contemplative quality of water, its unlimited horizon and

reflectivity, and its connection to the ever-changing nature of things: mortality, transformation, and the passage of time. Liz Deschenes, who responds to the curl of fast approaching waves, recognizes the sea as a very accessible popular subject whose real colors undermine expectations of travel brochure aquamarine. Robbert Flick references the reductive, calming quality of the sea, and its relationship to life and death, an association with the apocalyptic.

Roni Horn sees the symbolic, psychological, imaginative power of the ocean, and its traditional romantic role as terrifying and sublime. Stuart Klipper speaks of the nuances of change, of clarity, immediacy, and ahistoricity, the sea as bedrock to the nature of being. He adds that it is uniquely solipsistic and echoes soul-filling, profound aspects of human identity. Fernando La Rosa relishes the sea's balance of stillness and power, and the sensual, enveloping experience it offers. John McWilliams describes the suspension between the elements of air and water, and his attraction to the operatic adventure of the ocean's moment by

moment drama, and our insignificance to it. Tom Millea discusses the feelings evoked by such a primal, archetypal subject, the mother ocean. He considers the challenges of its many paradoxes and strong link to the unconscious. Michael O'Brien accepts the romance of the ocean, but responds most to the visceral component of its beauty. Serene one minute, and an out-of-control maelstrom the next: there is always something new for him to see.

Doug and Mike Starn identify the sea as constant and constantly changing on an immense and weighty scale. They honor its ties to the human psyche and its spiritual, symbolic function. Iain Stewart reacts to the contending notions of a quest or retreat brought on by the sea and its romantic associations. Hiroshi Sugimoto sees the seascape as an ancient vision, the most linked to a pre-historic condition of the earth. He also values its strength as an abstract subject and site for cultural comparison through the process of naming. James Welling is interested in the fluid, color-filled quality of the sea and sky combination, and the dynamic meeting of land and sea. Randy

West expresses the lure of the sea's tranquility and quiet. He is also drawn to its density, its minimalism, and the formality of the horizon line: a sight that is both sustaining and speaks of loss. And Hiroshi Yamazaki[9] remarks upon the ordinariness of an unmodified sea, a homogeneous place ripe for artistic exploration.

Yamazaki lives in Japan, a nation of islands where the sea surrounds and influences the physical experience of the land. Many of the other artists in *Sea Change* also live in such proximity to the sea, or have had determining, formative experiences with it.[10] They often have a relationship with their subject that is highly personal and imbued with nostalgia and private signification. They are coastal dwellers, surfers, sailors, or swimmers. Their seas are many, or are limited to one site: the Pacific off the Western United States, or the Asian-Pacific rim; the Atlantic off Maine, Long Island, or Northern Europe; the Mediterranean; the Caribbean; the Antarctic. Whether these places are deeply inscribed in the artists's identity, or are just the locale of a single excursion,

the balance between individual connection and the grand natural and social histories that inform our cultural understanding of oceans and their smaller cousins appears key to rebuilding the currency of the seascape genre.

Late in 1968, artist Vija Celmins brought her photographs of the ocean's surface made off Venice Pier in Los Angeles into her studio. There she recreated and reinterpreted the black-and-white studies as intensely detailed pencil drawings on paper primed with a light acrylic ground. Not interested in singular waves, she rendered the sea's tempered skin, a modulated surface "reacting to the pull of the tides and the unseen rhythms of its depths."[11] She claimed not to be a recorder of oceans, but to be creating a "record of mindfulness."[12] Her now landmark works are touchstones for the photography of *Sea Change*, a survey of images that return us to the concentration, the deep mindfulness that the sea compels.

1. Sylvia Alice Earle, *Sea Change: A Message of the Oceans*, xv.

2. Robinson Jeffers, "The Eye," in *Selected Poems* (New York: Vintage Books, 1965), 85.

3. Seascapes were prevalent in Pictorialist photography (early 1900s), a practice deeply intertwined with the example of painting. Seascapes were popular with California Pictorialists, particularly those of Japanese heritage.

4. Harold B. Nelson, *Sounding the Depths: 150 Years of American Seascape*, 73. See also, Avis Berman, "Modern American Seascapes: An Ancient Theme Rendered in a New Language," *Architectural Digest* 57 (July 1995): 114-119, 141.

5. Gerhard Richter, *The Daily Practice of Painting: Writings and Interviews 1962-1993* (Cambridge, Massachusetts: The MIT Press, 1995), 64.

6. Le Gray seamlessly combined negatives to allow for an ideal scene of resplendent seas and dramatic skies, otherwise technically difficult to achieve with a single exposure in the mid-19th century. Richter, on the other hand, mismatched color and black-and-white prints, stormy and calm imagery, even putting two sea images together with one positioned as the sky. See Eugenia Parry Janis, *The Photography of Gustave Le Gray* and Gerhard Richter, *Atlas: of the photographs, collages, and sketches*.

7. Harry Callahan, Afterword to *Water's Edge*, unpaginated.

8. Their comments were noted during phone conversations between the author and the artists in December 1997 and January 1998.

9. Hiroshi Yamazaki's comments were provided in writing, and in translation from Japanese.

10. See the biographical sketches in this volume for some indications of each artist's personal connection to the sea.

11. Susan Larsen, "Vija Celmins," in Betty Turnbull and Susan Larsen, *Vija Celmins: A Survey Exhibition*, 29.

12. Vija Celmins as quoted by Larsen, 30.

The exhibition

All works in the exhibition are listed alphabetically by artist, and then chronologically. Dimensions are given in inches; height precedes width. Illustrated works are indicated by a vertical rule.

South and Southwest from the South Jetty, Clatsop County, Oregon
1990
Gelatin silver print
14 ½ x 18" image; 16 x 20" sheet

Robert Adams

Southwest from the South Jetty, Clatsop County, Oregon
1990
Gelatin silver print
14 ½ x 18" image; 16 x 20" sheet
Collection of the Center for Creative Photography, The University of Arizona

Southwest from the South Jetty, Clatsop County, Oregon
1990
Gelatin silver print
14 ½ x 18" image; 16 x 20" sheet

Courtesy of the artist and Fraenkel Gallery, San Francisco, unless otherwise noted.

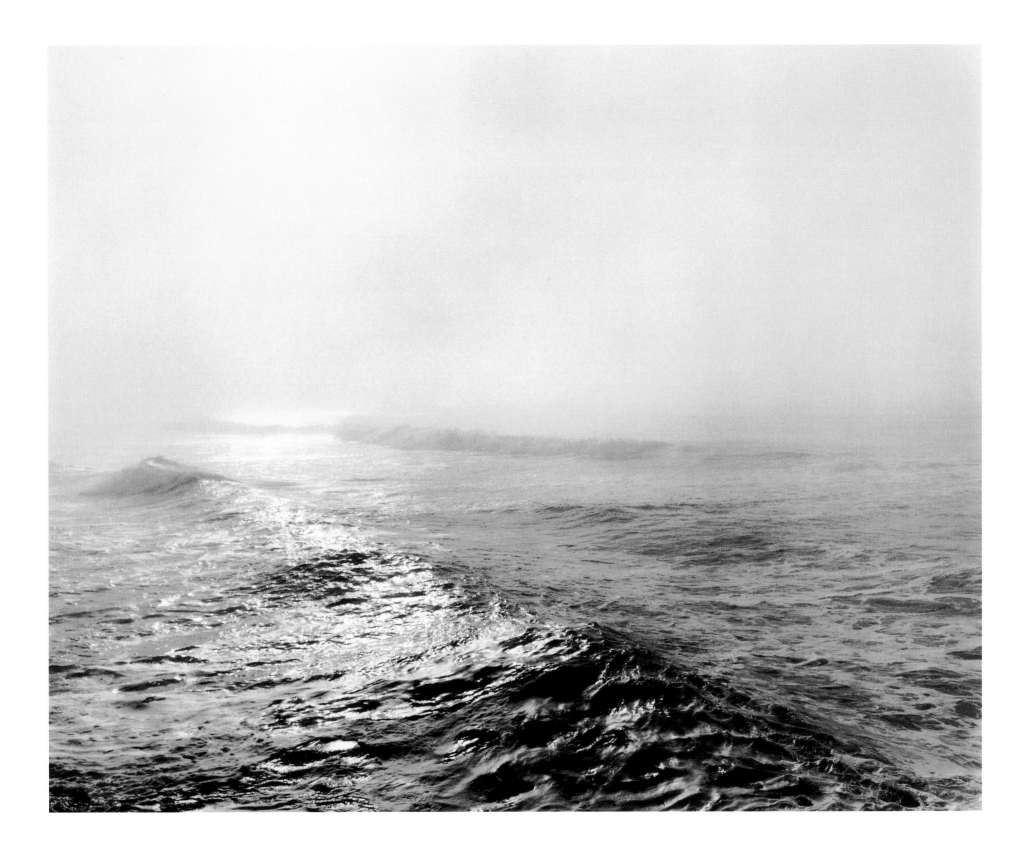

TOM BARIL

Jones Beach
1995
Toned gelatin silver print
34 x 26" image; 40 x 30" sheet
Courtesy of the artist; Bonni Benrubi Gallery, New York; and Robert Klein Gallery, Boston

Jones Beach '96
1996
Toned gelatin silver print
23 x 18" image; 26 x 20" sheet
Collection of the Center for Creative Photography, The University of Arizona

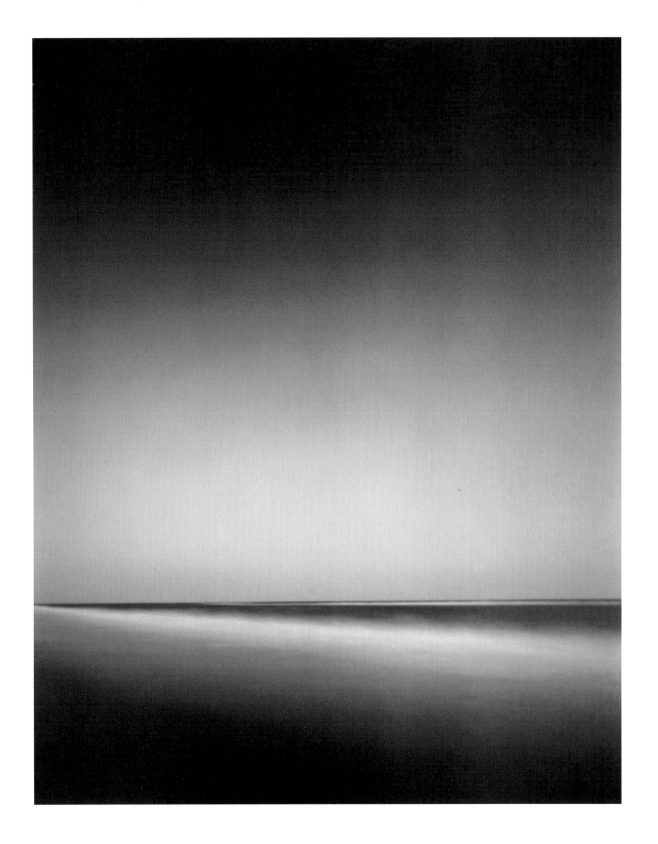

whirl

The Coryvreckan

(The largest whirlpool in Europe)
Jura/Scabra, The Inner Hebrides
Scotland
1991
Three selenium-toned gelatin silver prints
16 ½ x 22 ¾" each image; 20 x 24" each sheet

тhomas joshua cooper

Looking Towards the Old World

The Atlantic Ocean

The Bay of Fundy
West Quoddy Head
(The Easternmost Point of Continental America)
Maine, United States
1996/7
Selenium-toned gelatin silver print
28 x 37" image; 40 x 48" sheet

Courtesy of the artist and Sean Kelly Gallery, New York

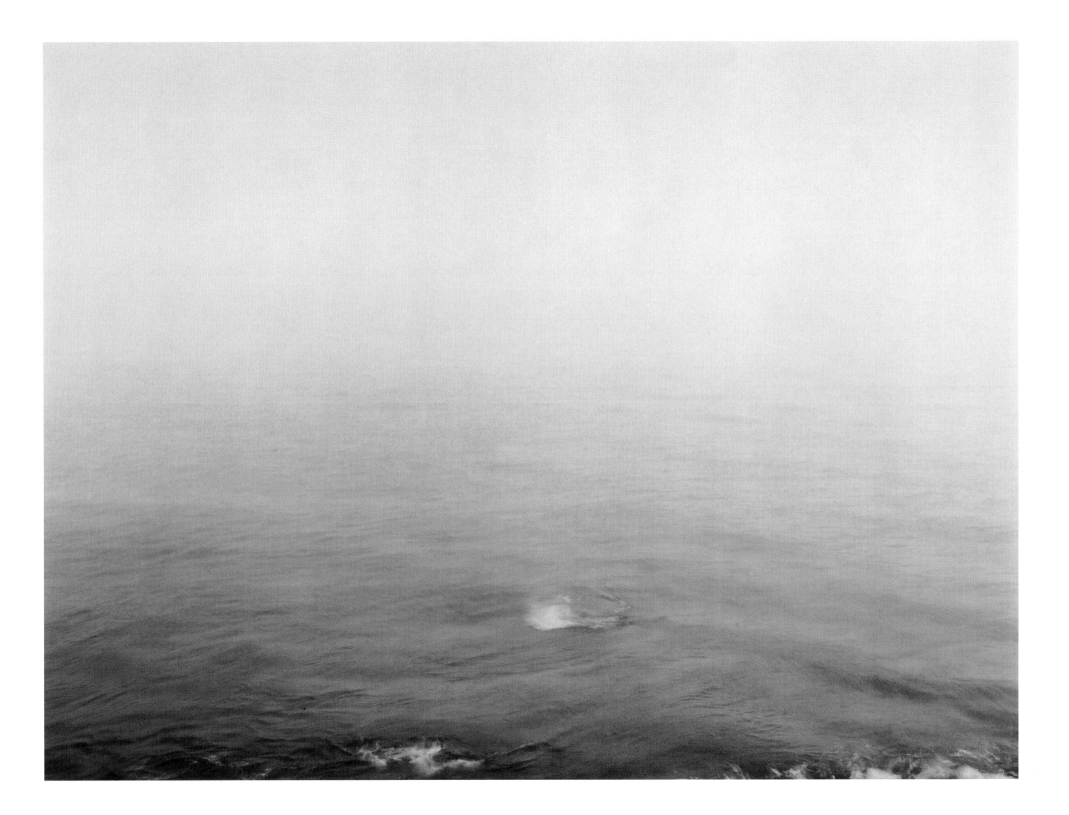

Evening/Northumberland Strait, #I
1993
Selenium-toned gelatin silver print
28 x 28" image; 40 x 30" sheet

Evening/Northumberland Strait, #IV
1993
Selenium-toned gelatin silver print
28 x 28" image; 40 x 30" sheet

Lynn Davis

Evening/Northumberland Strait, #VIII
1993
Selenium-toned gelatin silver print
28 x 28" image; 40 x 30" sheet

Evening/Northumberland Strait, #XVII
1996
Selenium-toned gelatin silver print
28 x 28" image; 40 x 30" sheet

Courtesy of the artist and Edwynn Houk Gallery, New York

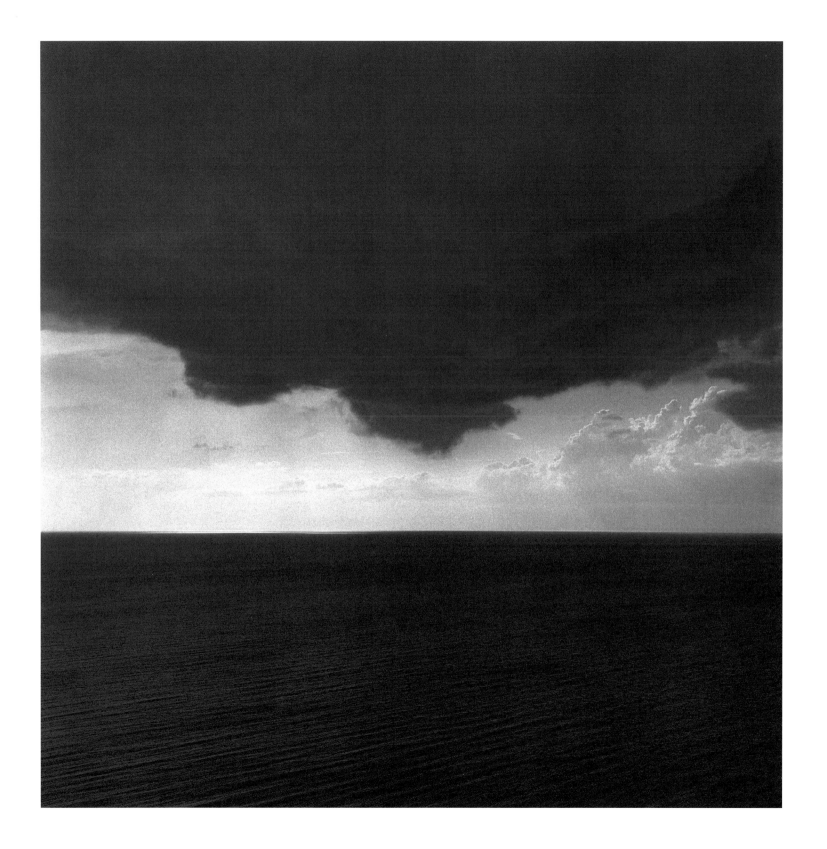

Color Study #5
1994-95
UV-laminated incorporated color coupler print mounted on glass
17 x 22 $\frac{1}{2}$" image; 20 x 24" sheet

Color Study #7
1994-95
UV-laminated incorporated color coupler print mounted on glass
22 $\frac{1}{2}$ x 17" image; 24 x 20" sheet

Color Study #11 [detail on cover]
1994-95
UV-laminated incorporated color coupler print mounted on glass
37 $\frac{1}{2}$ x 25 $\frac{1}{2}$" image; 40 x 30" sheet

Liz Deschenes

Color Study #13
1994-95
UV-laminated incorporated color coupler print mounted on glass
17 x 22 $\frac{1}{2}$" image; 20 x 24" sheet

Color Study #16
1994-95
UV-laminated incorporated color coupler print mounted on glass
17 x 22 $\frac{1}{2}$" image; 20 x 24" sheet

Courtesy of the artist and Bronwyn Keenan Gallery, New York

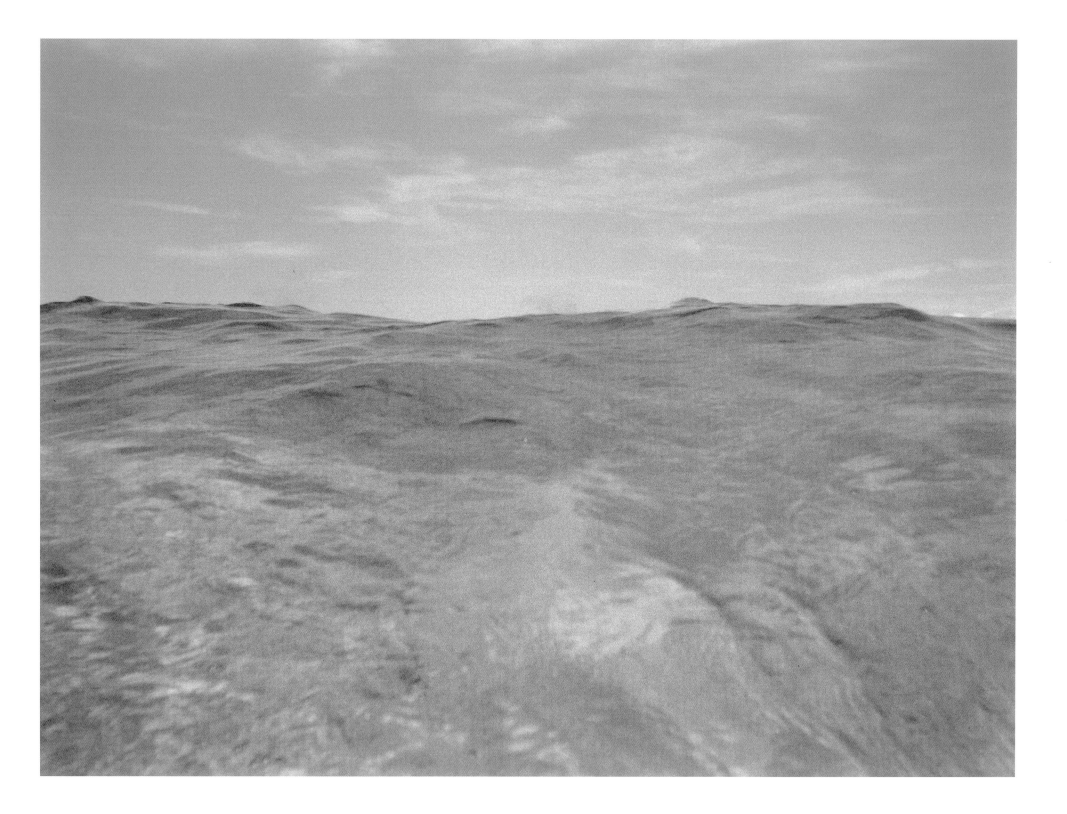

robbert flick

Surf1.Var2 [13-18 illustrated]
1997
Three Iris prints
34 x 35" each composite image; 35 x 36" each sheet
Collection of the Center for Creative Photography, The University of Arizona

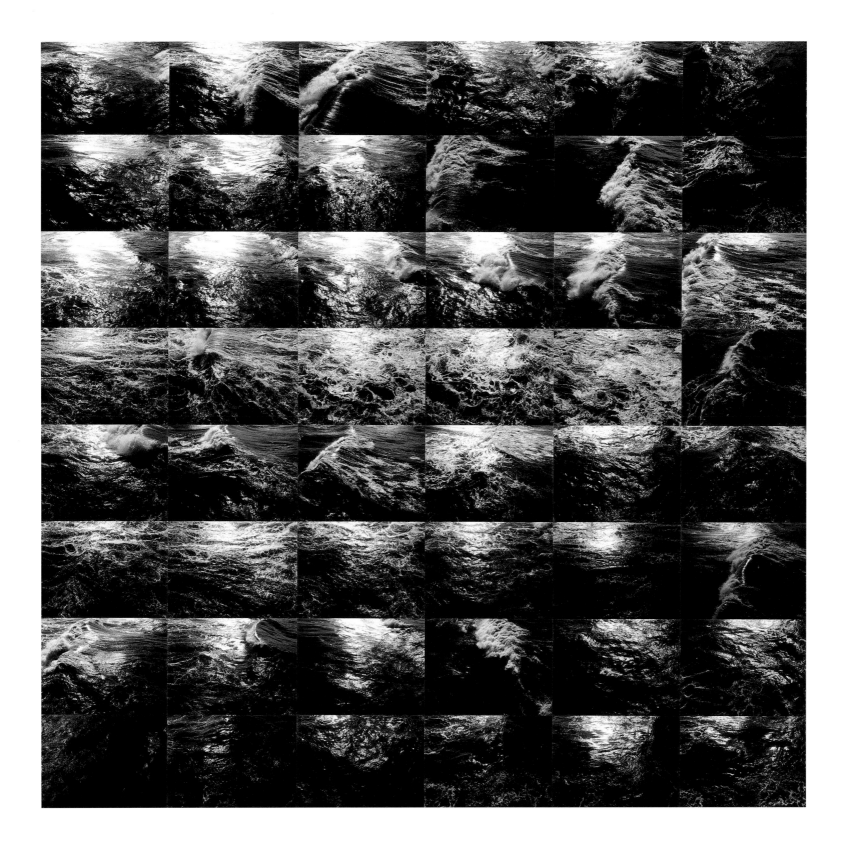

RONI HORN

Untitled (A Brink of Infinity)
1997
Photolithograph on uncoated paper
42 x 58"
Courtesy of Matthew Marks Gallery, New York

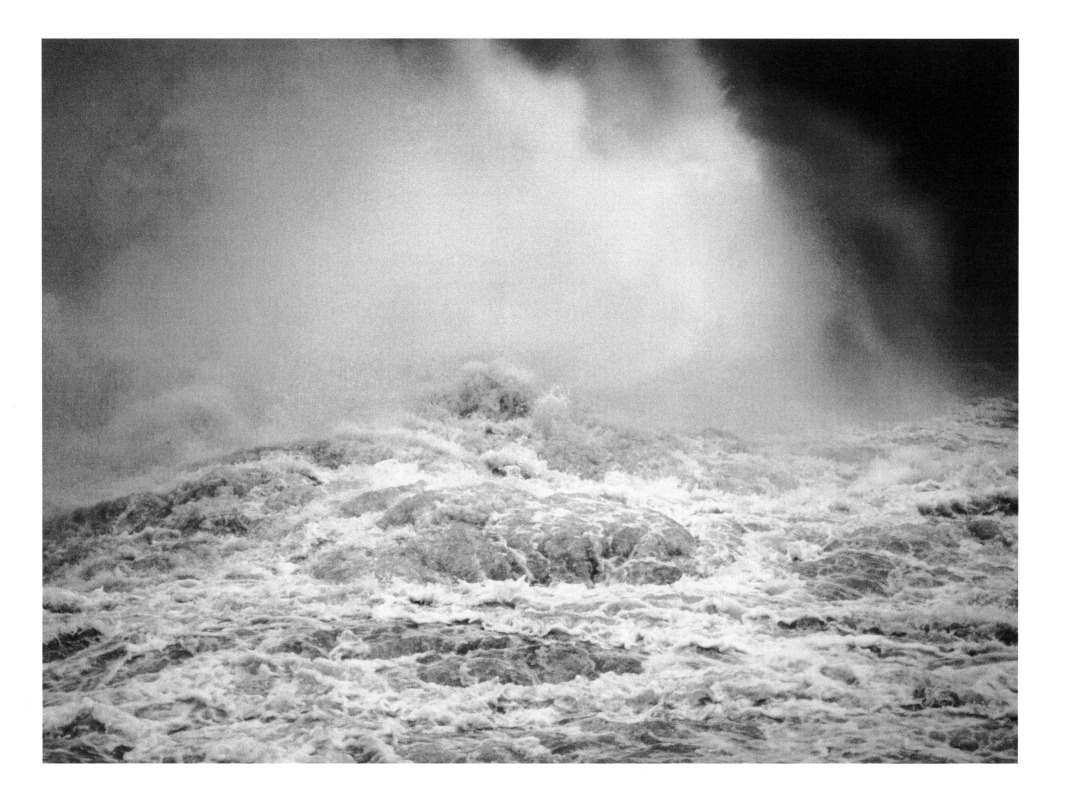

stuart klipper

Southeastern Pacific Ocean, Southwest of Tierra del Fuego
1987
from *Bearing South*
Incorporated color coupler print
12 x 38" image; 16 x 44" sheet
Collection of the Center for Creative Photography, The University of Arizona

Swell, 50° S, Southern Ocean
1992
from *On Antarctica II*
Incorporated color coupler print
12 x 38" image; 16 x 44" sheet

Swell, 50° S, Southern Ocean
1992
from *On Antarctica II*
Incorporated color coupler print
12 x 38" image; 16 x 44" sheet

Swell, 50° S, Southern Ocean
1992
from *On Antarctica II*
Incorporated color coupler print
12 x 38" image; 16 x 44" sheet

Courtesy of the artist, unless otherwise noted.

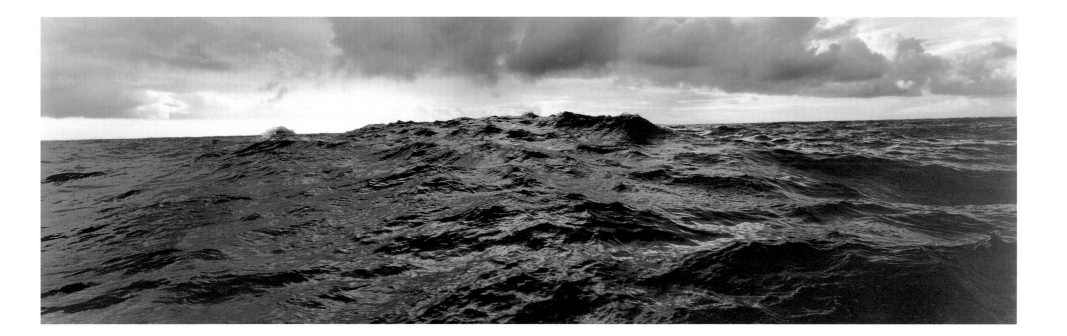

Four Squares, Jamaica
1987
Gelatin silver print
15 x 19" image; 16 x 20" sheet

Square, Jamaica
1987
Gelatin silver print
15 x 19" image; 16 x 20" sheet

fernando La Rosa

Gulf of Mexico
1995
Gelatin silver print
15 x 19" image; 16 x 20" sheet
Collection of the Center for Creative Photography, The University of Arizona

Horizon Line, Gulf of Mexico
1996
Gelatin silver print
15 x 19" image; 16 x 20" sheet

Courtesy of the artist and Sicardi-Sanders Gallery, Houston, unless otherwise noted.

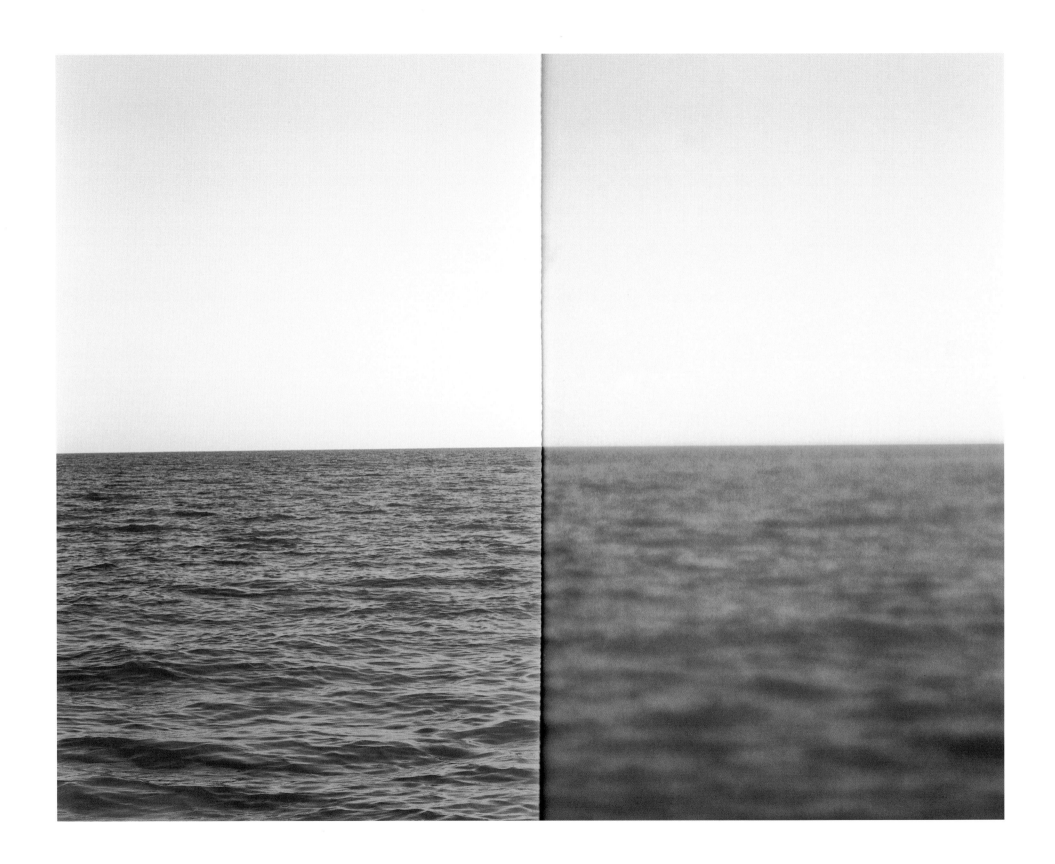

On the Edge of the Gulf Stream
1990
Gelatin silver print
12 ⅝ x 18 ¼" image; 16 x 20" sheet

john mcwilliams

Gray Backs
1991
Gelatin silver print
12 ⅝ x 18 ¼" image; 16 x 20" sheet

Rain Squall off Frying Pan Shoals
1995
Gelatin silver print
12 ⅝ x 18 ¼" image; 16 x 20" sheet

Courtesy of the artist and Jackson Fine Art, Atlanta

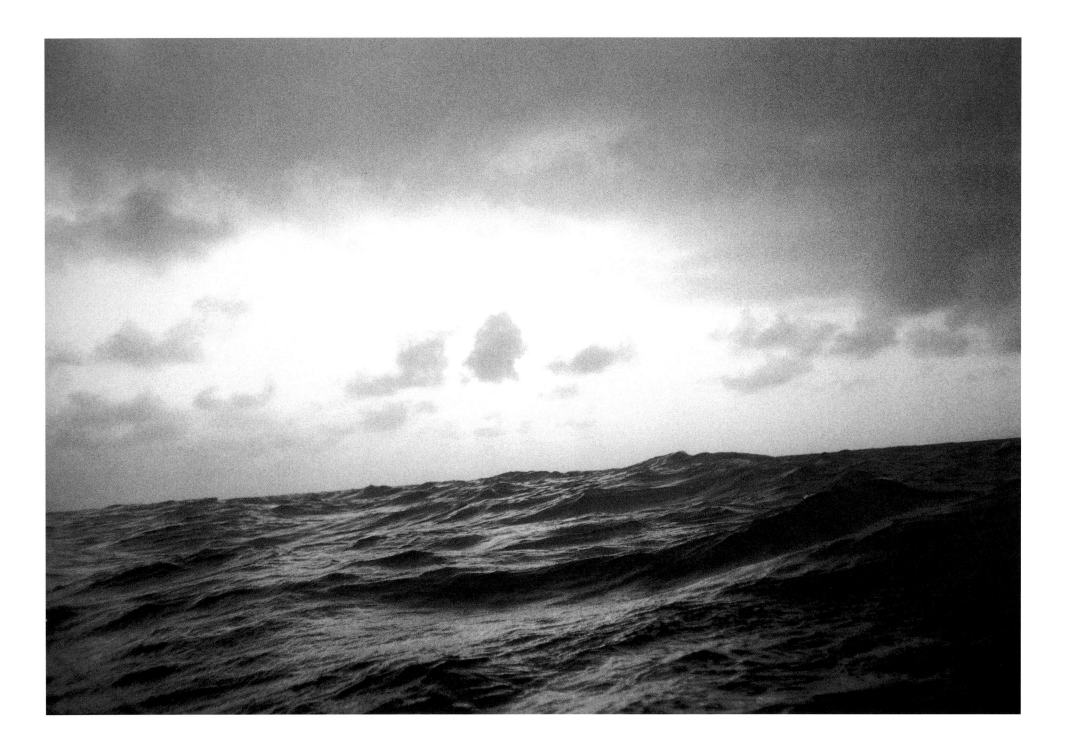

The Wave
1985
Platinum/palladium print
8 x 12" image; 11 x 14" sheet

Point Lobos
1989
Platinum/palladium print
7 ½ x 11 ¾" image; 11 x 14" sheet

Garrapata Beach
1992
Platinum/palladium print
8 x 12" image; 11 x 14" sheet

Tom Millea

Point Lobos, Sunset
1992
Platinum/palladium print
15 x 22" image; 22 x 30" sheet

Courtesy of the artist and Winfield Gallery, Carmel

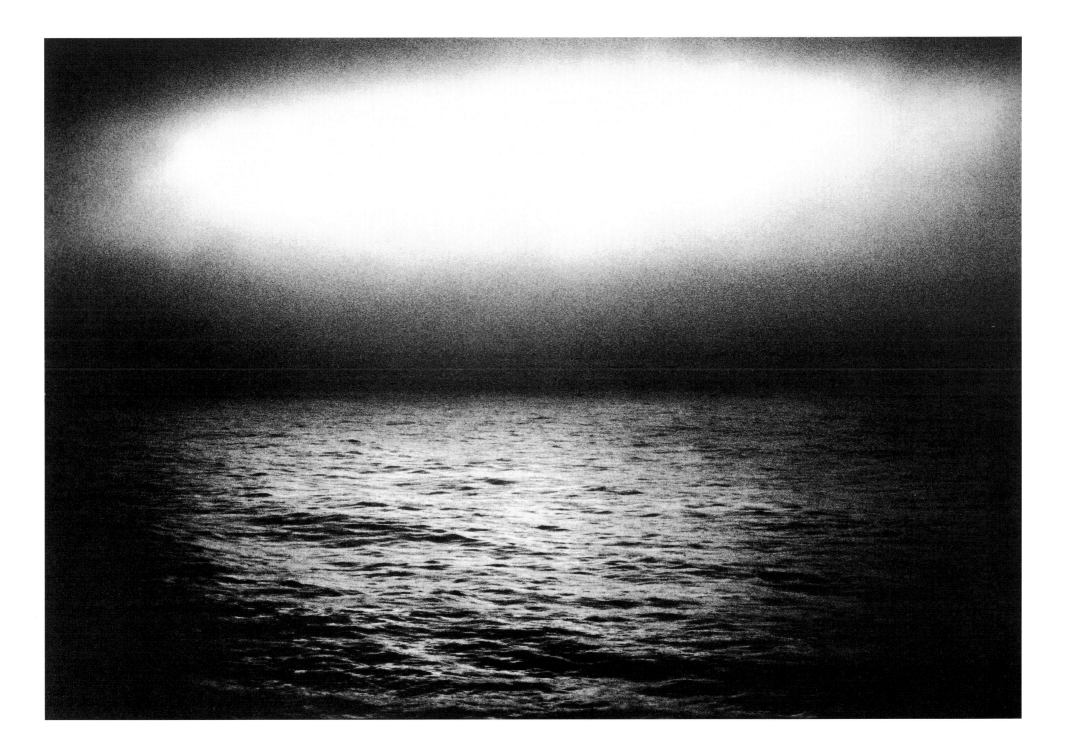

Untitled
1995
Incorporated color coupler print
44 x 30" image; 44 ½ x 30" sheet

michael o'brien

Untitled
1995
Incorporated color coupler print
47 x 30" image; 49 x 30" sheet

Untitled
1996
Incorporated color coupler print
46 x 30" image; 47 ¾ x 30" sheet

Courtesy of the artist

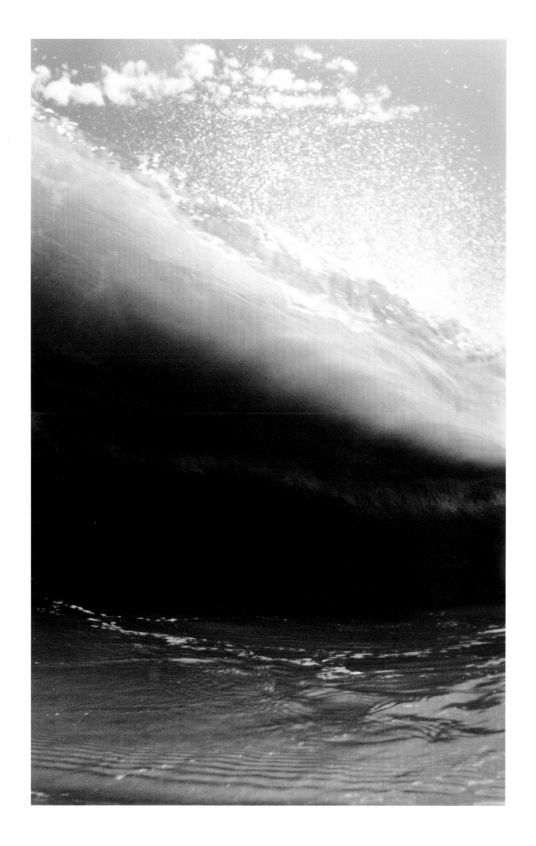

Doug and Mike Starn

Ocean in Fog
1996
Toned gelatin silver print, scotch tape
30 x 70"
Collection of the artists

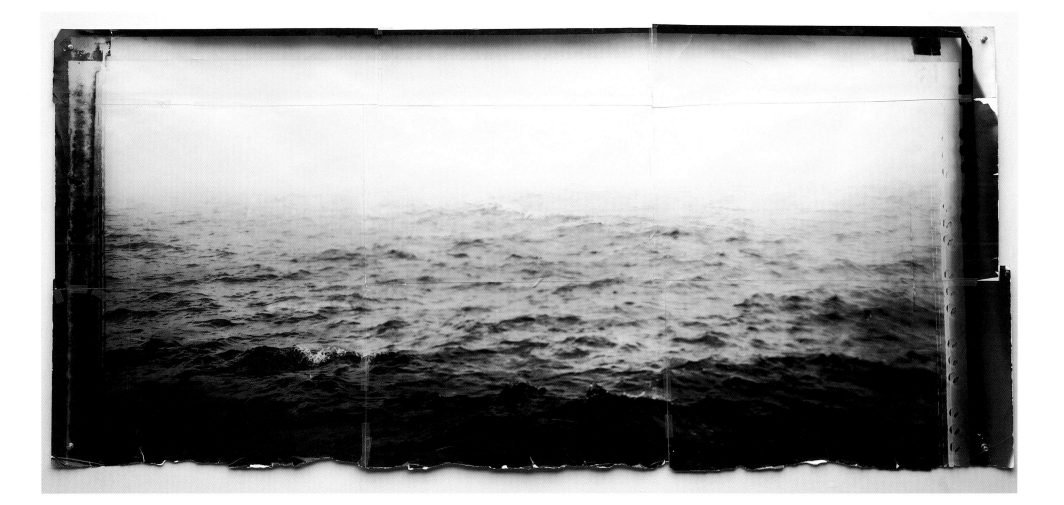

Iain stewart

Rhythm i-iii [*Rhythm i* illustrated]
1997
Three incorporated color coupler prints
15 x 15" each image; 16 x 20" each sheet
Collection of the Center for Creative Photography, The University of Arizona

Shift i-iii
1997
Three incorporated color coupler prints
15 x 15" each image; 16 x 20" each sheet

Return i-iii
1997
Three incorporated color coupler prints
15 x 15" each image; 16 x 20" each sheet

Courtesy of the artist and The Photographers' Gallery, London, unless otherwise noted.

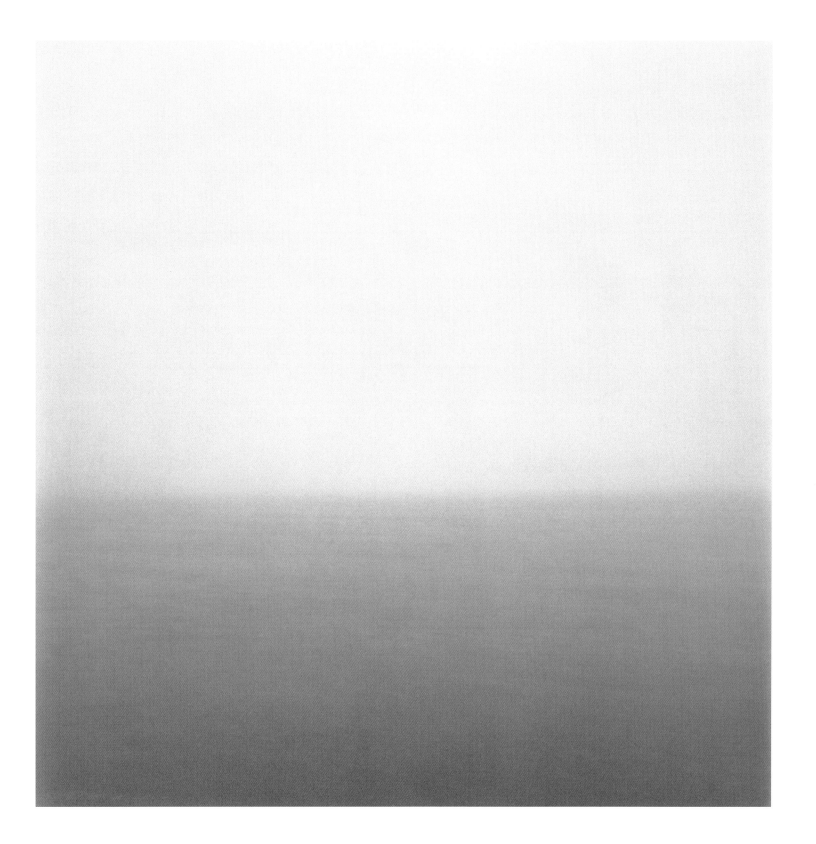

Gulf of Bothnia, Hornslandet
1996
Gelatin silver print
16 $\frac{1}{2}$ x 21 $\frac{1}{4}$" image; 20 x 24" sheet

Gulf of St. Lawrence, Cape Breton Island
1996
Gelatin silver print
16 $\frac{1}{2}$ x 21 $\frac{1}{4}$" image; 20 x 24" sheet

Hiroshi sugimoto

Kattegat, Kullaberg
1996
Gelatin silver print
16 $\frac{1}{2}$ x 21 $\frac{1}{4}$" image; 20 x 24" sheet
Collection of the Center for Creative Photography, The University of Arizona

Bass Strait, Table Cape
1997
Gelatin silver print
16 $\frac{1}{2}$ x 21 $\frac{1}{4}$" image; 20 x 24" sheet

Bay of Sagami, Atami
1997
Gelatin silver print
16 $\frac{1}{2}$ x 21 $\frac{1}{4}$" image; 20 x 24" sheet

Courtesy of the artist; Fraenkel Gallery, San Francisco; and Sonnabend Gallery, New York; unless otherwise noted.

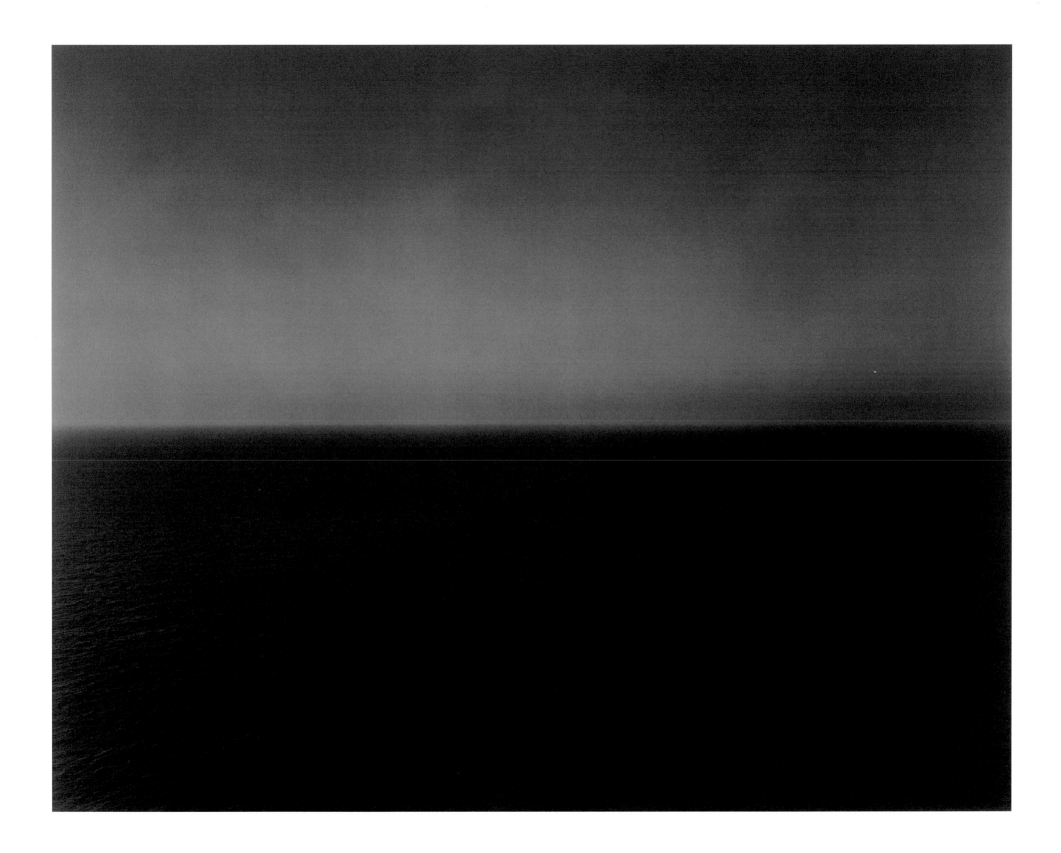

Seascape A, 1991
UltraStable color print
16 ¾ x 19 ¾" image; 16 x 20" sheet; 42 ¾ x 34 ¾" framed

james welling

Seascape F, 1991
UltraStable color print
9 x 11" image; 11 x 14" sheet; 24 x 19 ½" framed

Courtesy of the artist and Jay Gorney Modern Art, New York

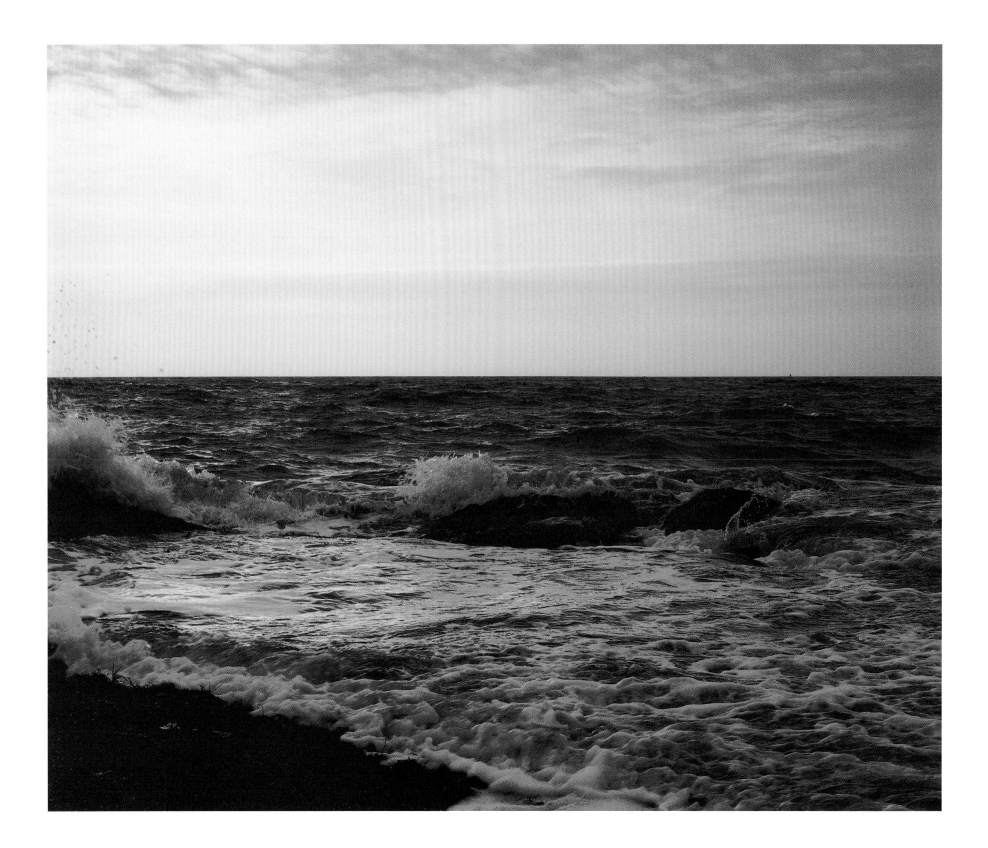

Untitled Seascape #1
1992
Photo linen, graphite
12 x 15 x $^3/_4$"

randy west

Untitled Seascape #2
1992
Photo linen, graphite
12 x 15 x $^3/_4$"
Collection of the Center for Creative Photography, The University of Arizona

Untitled Seascape #4
1992
Photo linen, graphite
12 x 15 x $^3/_4$"

Untitled Seascape #6
1992
Photo linen, graphite
12 x 15 x $^3/_4$"

Untitled Seascape #12
1992
Photo linen, graphite
12 x 15 x $^3/_4$"

Untitled Seascape #24
1992
Photo linen, graphite
12 x 15 x $^3/_4$"

Courtesy of the artist and Yancey Richardson Gallery, New York, unless otherwise noted.

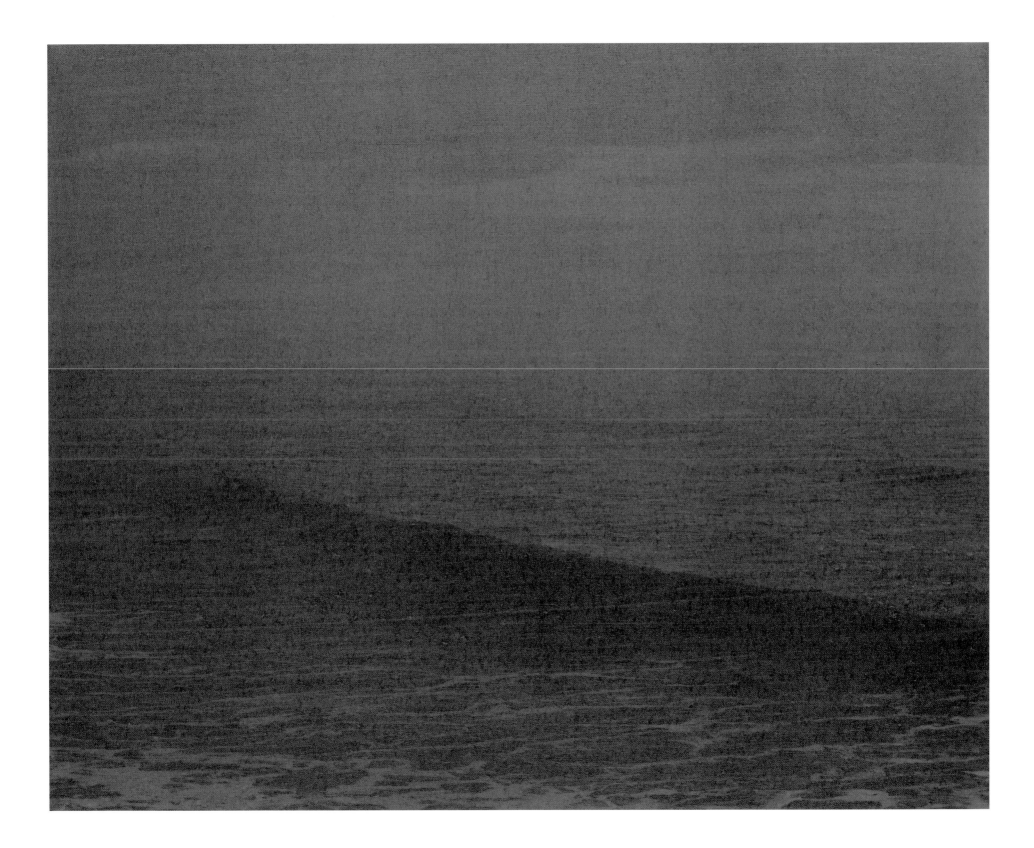

The Sun Is Longing for the Sea 1
1978
Gelatin silver print
8 x 12" image; 11 x 14" sheet

The Sun Is Longing for the Sea 2
1978
Gelatin silver print
8 x 12" image; 11 x 14" sheet

Hiroshi Yamazaki

The Sun Is Longing for the Sea 3
1978
Gelatin silver print
8 x 12" image; 11 x 14" sheet

The Sun Is Longing for the Sea 4
1978
Gelatin silver print
8 x 12" image; 11 x 14" sheet

The Sun Is Longing for the Sea 6
1978
Gelatin silver print
8 x 12" image; 11 x 14" sheet

Collection of the Center for Creative Photography, The University of Arizona; purchased with matching funds from Hitachi America, Ltd.

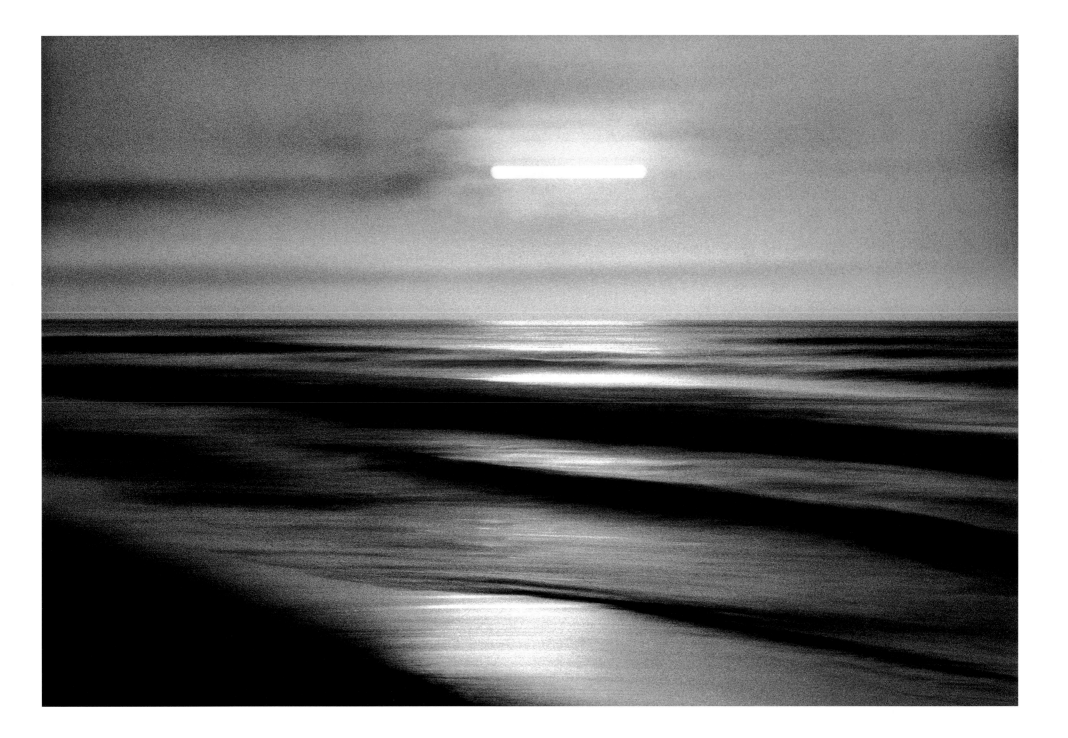

the artists

Robert Adams
Born 1937, Orange, New Jersey
Resides in Astoria, Oregon

Now relocated to the Northwest after over three decades in Colorado, Adams continues to photograph along the Oregon coast where the Columbia River joins the Pacific. A selection of this work was published as the book *West from the Columbia* (1995) and has been exhibited at the Denver Art Museum, Fraenkel Gallery in San Francisco, and with the 19th century seascapes of Gustave Le Gray at New York's Lowinsky Gallery. Adams was awarded a MacArthur Fellowship in 1994.

Tom Baril
Born 1952, Danielson, Connecticut
Resides in New York, New York

Baril began to make seascape photographs with a pinhole camera on beaches from Martinique to Hawaii to his native Long Island shore. The resulting images and other interpretations of classical genres have been exhibited at galleries in San Francisco, Chicago, Los Angeles, Boston, and New York City since 1995. *Tom Baril* (1997) is a substantial monograph devoted to the personal work of this photographer who first drew notice as Robert Mapplethorpe's printer.

Thomas Joshua Cooper
Born 1946, San Francisco, California
Resides in Glasgow, Scotland

As a graduate student in the early seventies, Cooper hitchhiked every weekend from New Mexico to California just to see the ocean. Waters are the subject of ninety percent of his recent photography, documented in numerous European publications and exhibitions with such titles as *The Swelling of the Sea*, *Simply Counting Waves*, and *Where the Rivers Flow*. Cooper founded the Department of Photography at the Glasgow School of Art in 1982 and continues to head that program.

Lynn Davis
Born 1944, Minneapolis, Minnesota
Resides in Hudson, New York

Davis redirected her photography after making a series of iceberg images at sea off Greenland in 1986. Abandoning studio work, she now travels to ancient monuments and elemental sites, including an array of water subjects: waterfalls, geysers, and the sea itself. Northumberland Strait, as seen from a cliff near her Nova Scotia home, is a restorative keynote. Lisette Model, Berenice Abbott, Robert Mapplethorpe, and Peter Hujar provided the friendships that are at the foundation of her photography.

Liz Deschenes
Born 1966, Boston, Massachusetts
Resides in New York, New York

A graduate of the Rhode Island School of Design in photography, Deschenes took up a disposable 35mm camera on a Caribbean vacation in 1994. Shooting waist-deep in the sea, she produced images that compelled her to return and complete the *Color Study* series a year later. Her exploration of color aesthetics, cultural conditioning and aquatic settings continues with her most recent subject, a Japanese indoor wave pool called Yokohama Blue.

Robbert Flick
Born 1939, Amersfoort, Holland
Resides in Claremont, California

Flick's long relationship with the sea begins in Holland and the Dutch West Indies and moves to the Pacific coast, from Los Angeles to British Columbia. In 1982, seeking to simulate an interior view of a wave, he photographed the passage of incoming surf from Manhattan Beach pier. He is still engaged by that sequence of exposures, having most recently recast them as a digital work. Represented by Craig Krull Gallery in Santa Monica, Flick is a professor of art at the University of Southern California and was a 1996-97 Getty Scholar.

Roni Horn
Born 1955, New York, New York
Resides in New York, New York

Horn received an M.F.A. from the Yale School of Art in 1978, three years after her first visit to Iceland, the island location that continues to inspire many of her installations and artist's books that include photography. Her search for Jules Verne's vision of the center of the earth informs several projects that elicit the sea, including her 1995 book *To Place: Verne's Journey*. Horn was featured in the 1997 Venice Biennale.

Stuart Klipper
Born 1941, New York, New York
Resides in Minneapolis, Minnesota

Klipper was three times invited to participate in the National Science Foundation's Antarctic Artists and Writers Program. He and his cameras have made Arctic and Antarctic voyages since 1981, in ships and under sail. Working in color and black-and-white, standard formats and panorama, he has photographed forty-eight large bodies of water. Klipper is a professor at The Colorado College and has received multiple grants from the National Endowment for the Arts, and the Guggenheim, Bush and McKnight Foundations.

Fernando La Rosa
Born 1943, Arequipa, Peru
Resides in Uniontown, Alabama

La Rosa's native Lima is endowed by the ocean with a perpetual fog that obscures any visible horizon. Using acetate frames in camera, he defeats the hard-line horizons of North American and Caribbean water views. He photographs on both continents, and is based in the American South where he received an M.F.A. (Tulane University) and has taught since 1989. In Peru, La Rosa recently published the novel *El Camino del Mono* (1997) and is scheduled for a career retrospective at the Museo de Arte de Lima.

John McWilliams

Born 1941, Pittsfield, Massachusetts
Resides in Atlanta, Georgia

A former professional boat builder and student of Harry Callahan, McWilliams built the 24 ½ foot ocean-worthy sailboat from which he makes many of his sea images. His ongoing project on low country culture enlarges upon the scenes he records hundreds of miles offshore. In 1995, McWilliams was named Director of the Georgia State University School of Art and Design where he has taught photography for almost thirty years. He has been a board member of the Nexus Contemporary Art Center since 1980.

Tom Millea

Born 1944, Bridgeport, Connecticut
Resides in Carmel, California

Millea, who has always lived on the water, has spent a quarter century within view of the Pacific Ocean. He often stops what he is doing to photograph the sea, claiming a moment when he and his subject are in tune. His platinum/palladium prints are in the collections of many major art museums. Millea recently curated the exhibition *Edward Weston at Home: The Carmel Work* for the Highlands Inn Gallery, and his CD-ROM, *Passage of the Heart: The Point Lobos Photographs*, was published in 1997.

Michael O'Brien

Born 1962, San Francisco, California
Resides in Jersey City, New Jersey

O'Brien describes himself as "a surfer kid from California who tries to make rockin' photographs of the ocean." In 1990, two years after his M.F.A. in Sculpture from the Maryland Institute of Art, he began to photograph breaking waves almost exclusively. Whether on his board, swimming, or standing in the surf, O'Brien uses a Nikonos underwater camera to photograph seas from Maui to Sandy Hook. His group exhibitions include a 1994 survey of seascape photography at East Hampton's Offshore Gallery.

Doug and Mike Starn

Born 1961, Somers Point, New Jersey
Reside in New York, New York

Identical twin brothers, the Starns are graduates of the School of the Museum of Fine Arts in Boston where they each won a competitive scholarship, the first of many distinguished awards. They have applied their exploration of the physicality and viability of photographic materials to numerous seascapes, drawn by the spiritual symbolism and vast scale of their subject. Since the 1987 Whitney Biennial, they have created various major installations, most recently for a 1998 show at Leo Castelli that marks a ten-year association with the gallery.

Iain Stewart

Born 1967, Sheffield, England
Resides in Edinburgh, Scotland

Stewart attended and now teaches at the Edinburgh College of Art. A relative newcomer to photography of the sea, he favors watery vistas for their potential minimalism and subtlety. Intentionally shooting in poor lighting conditions, he aims to suppress specific referents and construct a narrative from color and atmospheric detail. In 1994, Stewart undertook a series of portrait commissions for the Scottish National Portrait Gallery.

Hiroshi Sugimoto

Born 1948, Tokyo, Japan
Resides in New York, New York

Sugimoto made his first successful seascape in 1979 and has since assembled a striking inventory of the world's seas. Precisely bisecting the image with the horizon line, his approach has established a contemporary standard for seascape photography. He recently returned to the Bay of Sagami, location of his first formative childhood vision of the sea, to work at a single site. An exhibition to be held in Bielefeld, Germany, will present his seascapes with those of early 19th century German painter Caspar David Friedrich.

James Welling

Born 1951, Hartford, Connecticut
Resides in Los Angeles, California

A 1974 graduate of the California Institute of the Arts, Welling works discretely in abstraction and the documentary. His unresolved body of seascape imagery bridges divergent concerns with both pictorialist splendor and dispassionate inquiry into color. This series was first shown in Paris in 1992. Welling exhibits regularly in Europe where many catalogs of his work have been published. After nearly twenty years in New York, he has returned to Southern California to direct the photography program at UCLA.

Randy West

Born 1960, Indianapolis, Indiana
Resides in New York, New York

West holds a 1986 M.F.A. from the California Institute of the Arts where he was awarded an Alhmanson Full Scholarship. Confronting the Pacific coast after a life in the interior United States, he was overwhelmed by the ocean's presence. A swimmer, West accentuates water's isolating, opaque aspects in smoky graphite-covered photo linen works. His seascapes have been exhibited in galleries in Los Angeles, Minneapolis, New York, and San Francisco, and are in numerous private collections.

Hiroshi Yamazaki

Born 1946, Nagano, Japan
Resides in Tokyo, Japan

Yamazaki began to photograph the sea seriously in the early seventies, for awhile making it his sole subject. Seascapes account for half of his photography, particularly images that explore the relationship between the sea and the sun. Often working in time-based series, Yamazaki extends that approach to filmmaking and now videography. Two monographs of his sea pictures have been published in Japan: *Heliography* (1983) and *Horizon* (1989).

<small>selected</small> Bibliography

Abbe, Mary. "Stuart Klipper: Minneapolis Institute of Arts." *Art News* 92 (January 1993): 151.

Adams, Robert. *Beauty in Photography: Essays in Defense of Traditional Values*. New York: Aperture, 1981.

____. *Perfect Times, Perfect Places*. New York: Aperture, 1988.

____. *To Make It Home: Photographs of the American West*. New York: Aperture, 1989.

____. *West from the Columbia: Views at the River Mouth*. New York: Aperture, 1995.

____. *Why People Photograph: Selected Essays and Reviews*. New York: Aperture, 1994.

Anderson Spivy, Alexandra. "Lynn Davis, Studio Visit: A Life Changed by an Iceberg." *Art News* 91 (September 1992): 41-42.

Bachelard, Gaston. *Water and Dreams: An Essay on the Imagination of Matter*. Translated by Edith R. Farrell. Dallas: The Pegasus Foundation and The Dallas Institute of Humanities and Culture, 1983.

Baril, Tom. *Tom Baril*. New York: 4AD, 1997.

Benson, Richard and John Szarkowski. *A Maritime Album: 100 Photographs and Their Stories*. Newport News, Virginia, and New Haven: The Mariner's Museum and Yale University Press, 1997.

Brandt, Frederick R. *American Marine Painting*. Richmond: Virginia Museum, 1976.

Callahan, Harry. *Water's Edge*. Lyme, Connecticut: Callaway Editions, 1980.

Carson, Rachel. *The Sea Around Us*. New York: Oxford University Press, 1951.

Cikovsky, Nicolai and Franklin Kelly. *Winslow Homer*. Washington and New Haven: National Gallery of Art and Yale University Press, 1995.

Cooper, Thomas Joshua. *A Simples Contagem das Ondas/Simply Counting Waves*. Lisbon: Fundação Calouste Gulbenkian, 1994.

____. *Dreaming the Gokstadt*. Edinburgh: Graeme Murray, 1988.

Coote, John O., ed. *The Norton Book of the Sea*, 2 vols. New York: W.W. Norton and Co., 1994.

Corbin, Alain. *The Lure of the Sea: The Discovery of the Seaside in the Western World, 1750-1840*. Translated by Jocelyn Phelps. Cambridge: Polity Press, 1994.

Davis, Lynn and Rudolph Wurlitzer. "Lynn Davis: Stealing Time." *Grand Street* 59 (winter 1997): 122-131.

DiMichele, David. "Disappearing Acts: Randy West at Jan Kesner Gallery." *Artweek* 24 (20 May 1993): 25.

Earle, Sylvia Alice. *Sea Change: A Message of the Oceans*. New York: G.P. Putnam's Sons, 1995.

Farber, Thomas. *On Water*. Hopewell, New Jersey: Ecco Press, 1994.

Flick, Robbert and Minoru Shirota. *Robbert Flick: Sequential Views, 1980-1986*. Tokyo: Gallery Min, 1987.

Gaunt, William. *Marine Painting: An Historical Survey*. New York: The Viking Press, 1975.

Grundberg, Andy. *Mike and Doug Starn*. New York: Harry N. Abrams, 1990.

Hamilton-Paterson, James. *The Great Deep: The Sea and Its Thresholds*. New York: Random House, 1992.

_____. *Playing with Water: Passion and Solitude on a Philippine Island*. New York: Macmillan, 1987.

Harris, Melissa. "Lynn Davis." *Aperture*, no. 146 (winter 1997): 4-13.

"Hiroshi Sugimoto." *Parkett* 46 (May 1996): 119-153.

Holden, Donald. *Whistler Landscapes and Seascapes*. New York: Watson-Guptill Publications, 1969.

Horn, Roni. *To Place: Pooling Waters*, 2 vols. Cologne: Verlag der Buchhandlung Walther König, 1994.

_____. *To Place: Verne's Journey*. Cologne: Verlag der Buchhandlung Walther König, 1995.

_____. "Verne's Journey." *Parkett* 39 (March 1994): 131-143.

Jones, Malcolm. "The Littoral Truth: Turning his back on the continent, landscape photographer Robert Adams forages for beauty in the plainer corners of the Northwest coast." *Newsweek* 126 (13 November 1995): 88F.

La Rosa, Fernando. *Photographs: Frame Series 1978-1988*. Atlanta: Nexus Contemporary Art Center, 1988.

Lesy, Michael. "The Sailor" [on John McWilliams]. In *Visible Light*. New York: Times Books, 1985.

Little, Carl. *Winslow Homer and the Sea*. San Francisco: Pomegranate Artbooks, 1995.

Lloyd, Michael, ed. *Turner*. Canberra: National Gallery of Australia, 1996.

Loke, Margaret. "From a Printer to an Artist on His Own" [on Tom Baril]. *The New York Times*, 28 November 1997, sec. E-42.

McWilliams, John. *Land of Deepest Shade*. New York and Atlanta: Aperture and High Museum of Art, 1989.

Mejias, Jordan. "Die Spur des Verlorenen Sechsten Sinns: Tom Millea." *Frankfurter Allgemeine Magazin* 41 (10 October 1997): 8-16.

Melville, Herman. *Moby Dick*. New York: Vintage Books and Library of America, 1991.

Neill, Peter. *On a Painted Ocean: Art of the Seven Seas*. New York: New York University Press, 1996.

Nelson, Harold B. *Sounding the Depths: 150 Years of American Seascape*. San Francisco and New York: Chronicle Books and The American Federation of Arts, 1989.

Nixon, Bruce. "Robert Adams at Fraenkel Gallery." *Artweek* 27 (February 1996): 17-18.

Parry Janis, Eugenia. "Waves, Riggings, Ports: The Seascapes, 1855-1860." In *The Photography of Gustave Le Gray*. Chicago: The Art Institute of Chicago and the University of Chicago Press, 1987.

Raban, Jonathan. *The Oxford Book of the Sea*. Oxford and New York: Oxford University Press, 1992.

Richard, Frances. "Hiroshi Sugimoto: Sonnaband Gallery." *Artforum* 36 (September 1997): 123-124.

_____. "Roni Horn: Matthew Marks Gallery." *Artforum* 36 (December 1997): 118.

Richter, Gerhard. *Atlas: of the photographs, collages and sketches*. New York: D.A.P./Distributed Art Publishers, Inc., 1997.

Ruhmer, Eberhard. *Caspar David Friedrich Meereslandschaften*. Munich: R. Piper & Co. Verlag, 1978.

Sekula, Allan. *Fish Story*. Rotterdam and Düsseldorf: Witte de With and Richter Verlag, 1995.

Sischy, Ingrid. "Ice Was, Ice Will Be: A Floating Dimension, The Photographs of Stuart Klipper." *Artforum* 26 (October 1987): 108-112.

Springer, Haskell. *America and the Sea: A Literary History*. Athens: The University of Georgia Press, 1995.

Stein, Roger B. *Seascape and the American Imagination*. New York: Whitney Museum of American Art and Clarkson N. Potter, Inc., 1975.

Stilgoe, John R. *Alongshore*. New Haven: Yale University Press, 1994.

Stoll, Diana C. "Mike and Doug Starn." *Aperture,* no. 146 (winter 1997): 14-23.

Sugimoto, Hiroshi and Kerry Brougher. *Sugimoto*. Los Angeles: Museum of Contemporary Art, 1993.

Sugimoto, Hiroshi and Thomas Kellein. *Time Exposed*. London and New York: Thames and Hudson, 1995.

Sugimoto, Hiroshi, Maria Morris Hambourg, Dana Riis-Hansen and Atsuo Yasuda. *Sugimoto*. Houston: Contemporary Arts Museum, 1996.

Thijsen, Mirelle. "Thomas Joshua Cooper: *Landschap in het Fine de Siecle*." *Foto* 3 (March 1997): 47-54.

Turnbull, Betty and Susan C. Larsen. *Vija Celmins: A Survey Exhibition*. Los Angeles: Fellows of Contemporary Art, 1979.

Welling, James. *Light Sources*. Gent, Belgium: Imschoot, 1996.

_____. *James Welling: Photographs 1977-1990*. Bern: Kunsthalle Bern, 1990.

Wilmerding, John. *American Marine Painting*. New York: Harry N. Abrams, Inc., 1987.

Wilner Stack, Trudy and James Hamilton-Paterson. *Sea Change: The Seascape in Contemporary Photography*. Tucson: Center for Creative Photography, 1998.

Yamazaki, Hiroshi. *Heliography*. Tokyo: Seikyusha, 1983.

_____. *Horizon*. Tokyo: Rikuyo-sha Publishing, Inc., 1989.

Yau, John. "Hiroshi Sugimoto: No Such Thing as Time." *Artforum* 22 (April 1984): 48-52.

acknowledgments

The conception of this project took place years before its final realization, and I thank all those friends and colleagues who encouraged its pursuit from the beginning. I also thank those involved who were patient with its development and who responded to our search for photographic artists who had turned to the sea in the last twenty years. The continuing enthusiasm and confidence of CCP Director Terence Pitts, and Assistant Director Nancy Lutz, make such undertakings imaginable. I am particularly grateful to Nancy, who gave seascapes a chance and even fell under their spell, all the while helping to put the needed resources in place to complete the project.

The remaining CCP staff came together in a coordinated effort that is typical of their commitment to our work. I would like to thank all of them, especially Laura Downey, Cass Fey, Dustin Leavitt, Betsi Meissner, Tim Mosman, Dianne Nilsen, Keith Schreiber, Claudine Scoville, Nancy Solomon, Vi Spence, Anne Sullivan, Marcia Tiede, Tim Troy, and student curatorial assistant Rosey Truong.

April Watson got *Sea Change* rolling, and Curatorial Assistant Pat Evans has kept its enormity of details under control with characteristic humor and practicality. Her dedication never wanes and it has been a pleasure to share this with her every step of the way.

Graphic designer Bill Kobasz of Reliable Design Studios, Inc. is a longtime favorite collaborator. His sympathies were perfect for this project, as is reflected in his exquisite catalogue design. His participation is always an assurance of excellence and I thank him for his willingness to join us. This publication was also favored with an essay on the perception of oceans through Western history by a British writer with a well-established command of the sea as subject, James Hamilton-Paterson, author of *The Great Deep: The Sea and Its Thresholds*. He too understood our project in a way that ensured a contribution whose insights complement and expand upon the images of the artists. Additional thanks go to his literary agent Andrew Hewson. Sharon Gallagher

at D.A.P., Distributed Art Publishers, also took on our project, and we appreciate her skillful handling of the commercial distribution of this catalogue.

Nineteen artists have been brought together to explore the contemporary seascape in photography, and we thank each of them and their representatives for agreeing to take part and generously following through with their time and attention. They are Robert Adams, and Frish Brandt and Amy R. Whiteside at Fraenkel Gallery; Tom Baril, and Bonni Benrubi and Karen Marks at Bonni Benrubi Gallery; Thomas Joshua Cooper, and Sean Kelly Gallery; Lynn Davis, and Susan Arthur Whitson at Edwynn Houk Gallery; Liz Deschenes, and Bronwyn Keenan Gallery; Robbert Flick; Roni Horn, and Jeffrey Peabody at Matthew Marks Gallery; Stuart Klipper; Fernando La Rosa; John McWilliams, and Jane Jackson at Jackson Fine Art; Tom Millea, and Swanstock, Inc.; Michael O'Brien; Doug and Mike Starn, and Larra Nebel at their studio; Iain Stewart; Hiroshi Sugimoto,

and Frish Brandt and Debbie Berne at Fraenkel Gallery; James Welling, and Rodney Hill at Jay Gorney Modern Art; Randy West; Hiroshi Yamazaki, and PGI Gallery. The artists graciously and agreeably spoke to me about their work with the sea, and I am indebted to them for their interest in our endeavor. Large, thematically organized exhibitions of this nature require a leap of faith, so the good will of all the participants was greatly welcome.

No project of mine is without Michael Stack and Eleanor Wilner; their wisdom and sense inflect many of the decisions that shape my work. Mike and Noah Stack also helped me through a year that brought us a family sea change, the addition of Molly Sienna Stack.

On behalf of the Center for Creative Photography, we extend our gratitude to Lannan Foundation, the National Endowment for the Arts, the Arizona Commission on the Arts, and the individuals who award and administer the grants which make *Sea Change* and its educational programs possible.

The existence of these organizations and agencies offers a future to special projects that would otherwise remain only promising ideas.

Trudy Wilner Stack

Exhibition Curator and Curator of Exhibitions & Collections, Center for Creative Photography